Flowers in Watercolour

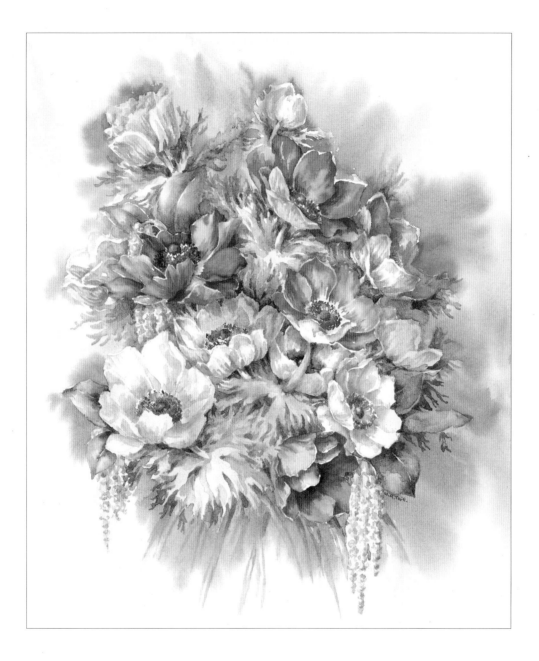

To my husband Harry, for all his love and encouragement and the fact that he never stops believing in me.

Flowers in Watercolour

WENDY TAIT

SEARCH PRESS

First published in Great Britain 1999

Search Press Limited
Wellwood, North Farm Road,
Tunbridge Wells, Kent TN2 3DR

Text copyright © Wendy Tait 1999

Photographs by Search Press Studios
Photographs and design copyright © Search Press Ltd. 1999

ISBN 0 85532 903 3

The Publishers and author can accept no responsibility for any
consequences arising from the information, advice or instructions
given in this publication.

The publishers would like to thank Winsor & Newton for
supplying many of the materials used in this book.

Suppliers
If you have difficulty in obtaining any of the materials and
equipment mentioned in this book, then please write to the
Publishers at the address above, for a current list of stockists,
including firms who operate a mail-order service. Alternatively,
write to Winsor & Newton requesting a list of distributers.

Winsor & Newton, UK Marketing
Whitefriars Avenue, Harrow,
Middlesex HA3 5RH

Colour separation by Graphics '91 Pte Ltd, Singapore
Printed in Spain by Elkar S. Coop. Bilbao 48012

*Sincere thanks to my father, who bought me my
first box of paints; to my mother for passing on her
spark of creativity; and to my tutor who inspired
me. Also, thanks to my special friends and pupils
who (sometimes unwittingly) have helped me with
their comments and criticisms; and to Roz and
Chantal who have guided me through the process
of writing this book.*

Page 1
Anemones
*These wonderful anemones were bought off a market stall.
They lasted all week in a cool place, obediently closing at night
and opening the next day. They were painted using cobalt
blue deep, Winsor violet, quinacridone magenta, Winsor
orange, Winsor lemon, Payne's gray and my green mix (see
page 11).*

Pages 2–3
Daffodils, irises and jonquils
*Lots of different tones of yellow, blue and green were combined
with diagonal movement to give a fresh feel to this painting.*

Opposite
Spring flowers
*This wonderful selection of flowers was collected from my
garden. If you want to pick crocuses, you will find that you
have to work fast, as these flowers open quickly once brought
indoors.*

Publishers' note
All the step-by-step photographs in this book feature the
author, Wendy Tait, demonstrating how to paint flowers in
watercolour. No models have been used.

There is a reference to sable hair and other animal hair
brushes in this book. It is the Publishers' custom to
recommend synthetic materials as substitutes for animal
products wherever possible. There are now a large number of
brushes available made from artificial fibres and they are
satisfactory substitutes for those made from natural fibres.

Contents

Introduction

Everyone has their own way of painting and no two ways are the same. There is not a 'right way' if it does not work for you, nor a 'wrong way' if you like the effect. This book is about the way I paint and enjoy painting but I hope it gives you one or two tips on how to make your own style work for you.

I will show you how to paint a misty background and how to pull flowers out of it, deepening around and behind each flower instead of overpainting it. You will also learn how to draw with your brush, rather than with a pencil – this avoids the rubbing out that inevitably follows! There are examples of flowers painted straight on to dry white paper with just a little background added later. Some people find this method relatively easy, but it has many pitfalls, including the fact that you run the risk of ruining the work you have already done. I prefer to begin with a gentle background in the colour range of the flowers I am using, and to then build my painting from there, finishing with the tiny darks that give the all important contrasts.

I am often asked which are my favourite flowers, but I find it difficult to name them. Each season I look forward to a change of subject as I (almost) always paint from the actual flower.

Good painting depends on good observation, but

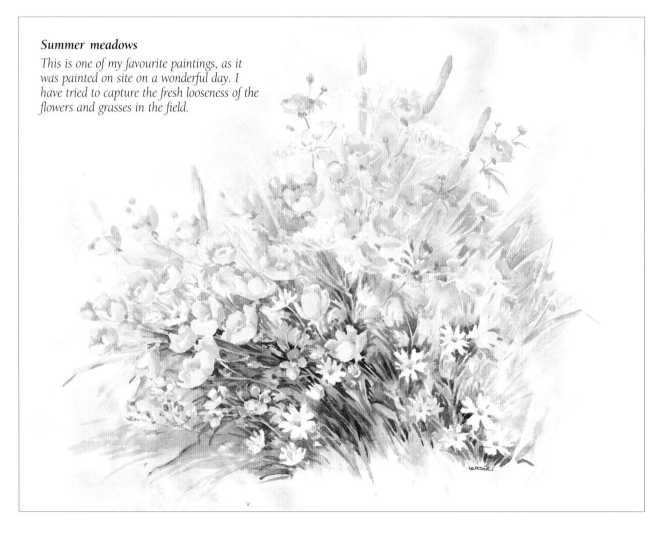

Summer meadows

This is one of my favourite paintings, as it was painted on site on a wonderful day. I have tried to capture the fresh looseness of the flowers and grasses in the field.

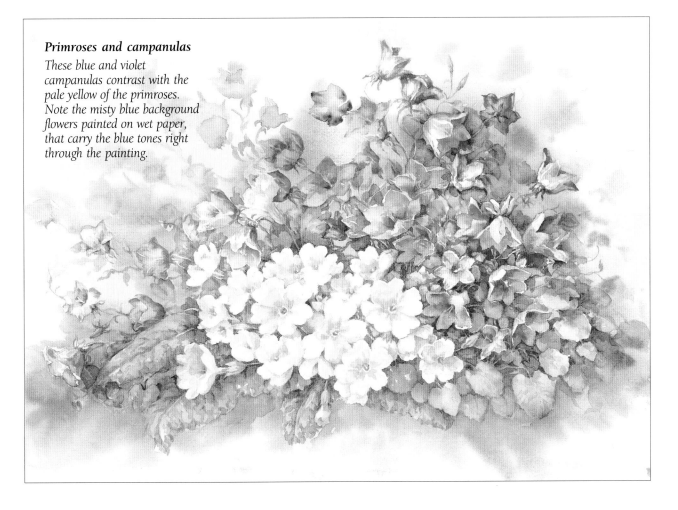

Primroses and campanulas

These blue and violet campanulas contrast with the pale yellow of the primroses. Note the misty blue background flowers painted on wet paper, that carry the blue tones right through the painting.

a successful painting can often depend on what is suggested but not painted in detail. The imagination will supply the eye with the necessary information if led in the right direction. I do not try to paint botanical illustrations, but rather to suggest the feeling of the flowers, the season, even the smell. I really want to appeal to the emotions of the viewer.

The excitement of the clean white paper, the feeling that this is going to be *the* masterpiece – this is what keeps me painting. Usually, I fall into the same traps as most of us do, make the same mistakes and by the time I get halfway through, I realise that the masterpiece is just as far away as ever! However, I am still held by the sheer pleasure of paint, brush, paper and the magic of adventure!

I have included some part-worked paintings which show the stages I go through before deciding that a painting is complete. Deciding this is quite a

milestone as it is so easy to take things a little too far and become 'fiddly'. Timing is of the essence at every stage! When I think I have finished a painting, I usually prop it up in my studio for several days, occasionally looking at it to decide whether it is successful and can be mounted and framed, whether it will be consigned to the pile of nearly-made-it-but-not-quites, or whether it is frankly awful. Even if I think a painting is a failure, I still keep it, as it often helps to remind me of areas that did work, even if I subsequently ruined it. Time spent painting is never wasted. Whether a painting is successful or not is often a question of personal choice anyway. The main aim should be to practise, practise, practise.

I hope it is the same for you, and that just one little tip or idea in this book will start you off on your own voyage of discovery.

Materials and equipment

The following materials are my choice but they are not necessarily the best for your particular style of painting. Experiment until you find what suits you best.

Paints

Paints are available in pans and tubes. I use tubes because they give me a rich creamy colour immediately, whereas pans sometimes take a little working at. Some people prefer to use pans – there are no rules, just choose whichever suits you best.

Brushes

There are a variety of brushes available. Sable are the best quality as they hold the colour well, but you can also use sable and ox-hair blends or synthetic brushes. I use Nos. 6, 10 and 12 synthetic. I find these firmer than sable and not nearly as expensive. I also use a hake brush for applying water to the paper.

Note If you buy paper in block form, you will not need to stretch it before applying washes – no matter what weight it is.

If you buy it in sheet form, you will need to work on a drawing board. The paper can be attached with masking tape to give a good solid painting surface.

Paper

There are many papers available. You can buy sheets, pads or blocks. Blocks are gummed all round the edges and the sheets do not need stretching. There are a choice of surfaces: Hot Pressed (H.P.) has a smooth surface; NOT, or Cold Pressed, has a slight texture; Rough has a good texture. I usually use NOT, and I prefer Italian paper in a block.

Light-weight papers (anything under 300gsm (140lb)) – require stretching to prevent sheets from cockling when washes are applied. Medium-weight papers (the most widely used is 300gsm (140lb)) may still need to be stretched, depending on how wet you like to work. The heavier papers (425–600gsm (200–300lb)) do not need stretching and will stand any amount of rough treatment.

Other items

Water pot Mine is divided into three. One section has a ridged bottom which holds the sediment; this means you always have clean water.

Clean rag This is essential for control of colour and water on the brush. Absorbent paper may be used instead.

Easel I find it best not to clamp my paper into an easel as I like to have freedom of movement. You may suddenly need to tip your painting to let the colour flow in certain directions. However, a light-weight sketching easel, like the one shown here, is useful for outdoor and studio work.

Soft pencil I do not usually use a pencil but prefer to draw with the brush (this is easier than you think). If you find this too difficult, you can sketch in your flowers lightly using a soft pencil.

Choosing your colours

My palette

Different palettes are needed for different subjects – for example, a flower palette uses a lot of pinks and violets instead of the earth colours you would expect to use for a landscape.

I use a large plastic palette because it is inexpensive, light and easy to clean. I tend to clean out only the mixing areas after finishing a painting, not the wells of colour. When I mix my colours, I always squeeze the colours out in the same order. It makes the selection of colours easier if you know where they are. I like to decant two Winsor lemons (one to keep pure and the other for my basic green mix with Payne's gray) and two cobalt blue deeps (again, one to keep pure, the other to mix from). I find I squeeze out the majority of my colours each time I paint, as I never know when a touch of something I do not often use, will supply just the tone I need.

I never use white, mainly because my first art tutor taught me not to. However, this is a matter of personal preference. Also, I like the paper to shine through pale washes and for this reason, most of my colours are transparent. Winsor orange is the only one that is semi-opaque, so I use this very sparingly.

When you have finished painting for the day, drop your palette into a plastic bag with a paper towel over it to mop up any excess liquid. This will stop paint from spreading on to other materials in your bag.

The colours below are listed in the order that they are placed on my palette.

Cobalt blue deep

Ultramarine violet

Winsor violet

Brown madder

Winsor orange

Quinacridone magenta

Scarlet lake

Permanent rose

Quinacridone gold

Raw umber

Raw sienna

New gamboge

Payne's gray
Winsor lemon — (basic green mix)

I always place my paints in a set order in my palette so I can locate them easily. I usually have two compartments for Winsor lemon and cobalt blue deep – one of each to keep pure, the other for mixing.

Colour mixing

The mixes on this page are included to give a few very simple ideas. Experiment by putting one pool of colour, e.g. Winsor orange, next to, say, a pool of quinacridone magenta. Gently overlap the edges of the colour, not the whole puddle; tease it out over the clean area and strengthen it until you have several tones of pink, orange and red. As the colour dries on the palette, these are valuable sources of different tones of the colour. The last examples on the chart below, show pale mixes of the colours I would use to shadow very pale or white flowers.

Violet is a must. It has so many uses – particularly in shadows for autumn subjects, but it also makes a wonderful colour for the centre of pansies when added to brown madder. When I refer to violet in this book, it is usually to Winsor violet; ultramarine violet and scarlet lake are in my palette for very occasional use. If you do not have a violet and need to mix one, you will soon discover that any old red and blue do not make violet – they make mud. Use a blue-based red, such as permanent rose or quinacridone magenta, added to cobalt blue deep.

> **Note** I never use green straight from the tube as I find it can be very garish. I prefer to mix my own greens from Winsor lemon and Payne's gray, adding cobalt blue deep to cool it, or quinacridone gold or raw sienna to warm it.
>
> When mixing washes, think about the ratio of pigment to water. Remember that as you work through your painting, you will need lots of water to begin the background washes, then progressively less as you move towards more detailed work.

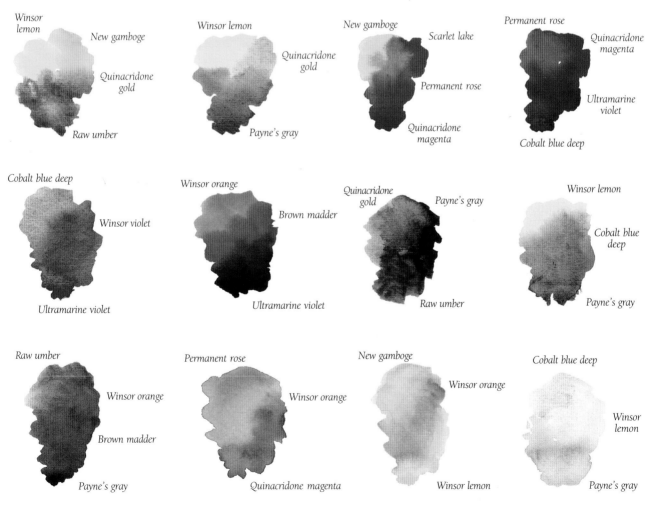

11

Cool colours

If you use cool tones in a painting you can give the feeling of climate rather than direct botanical illustration. Here I have used predominantly pale mixes of lemons, blues and greens.

Daffodils and primroses

Cool colours are used in these pale flowers early in the season. Their freshness is contrasted with a bluey violet mix in the background, with added strength behind the central flowers. The colours I have used here are cobalt blue deep, Winsor lemon, new gamboge, Winsor violet, permanent rose and a basic green mix (see page 11).

Warm colours

A warm painting will have the emphasis on pinks and reds. Your initial palette may be exactly the same as for a cool painting, but you simply change the proportions of mixes to achieve the effect of more warmth. For example, add tiny amounts of orange to pinks, to create more reds.

Sweet peas

Although this painting uses mainly the same colours as the one opposite, I have changed the balance towards warmth by creating more pinks and reds and by adding more violet to the background. The colours used are cobalt blue deep, Winsor violet, quinacridone magenta, permanent rose, Winsor orange and the basic green mix (see page 11).

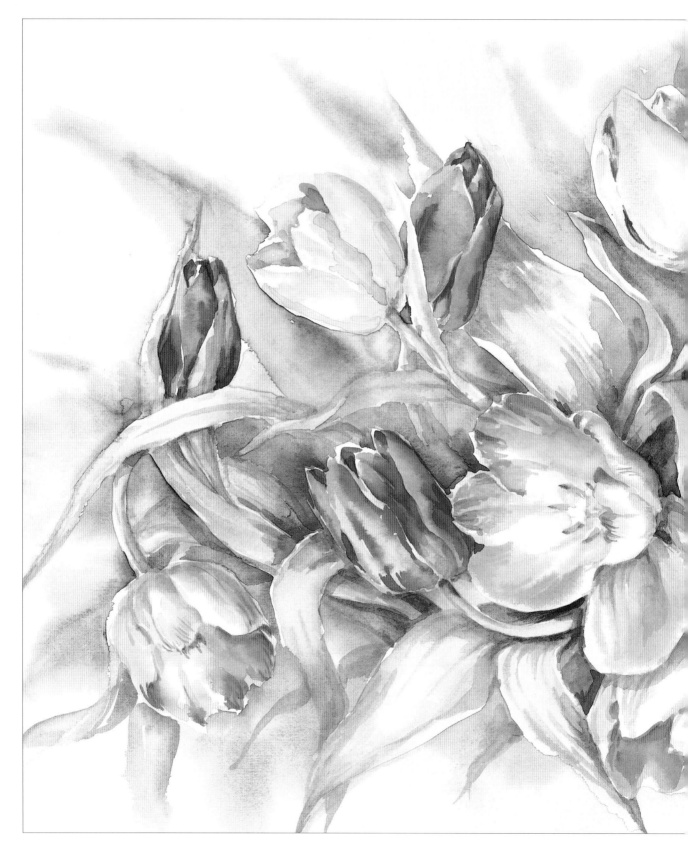

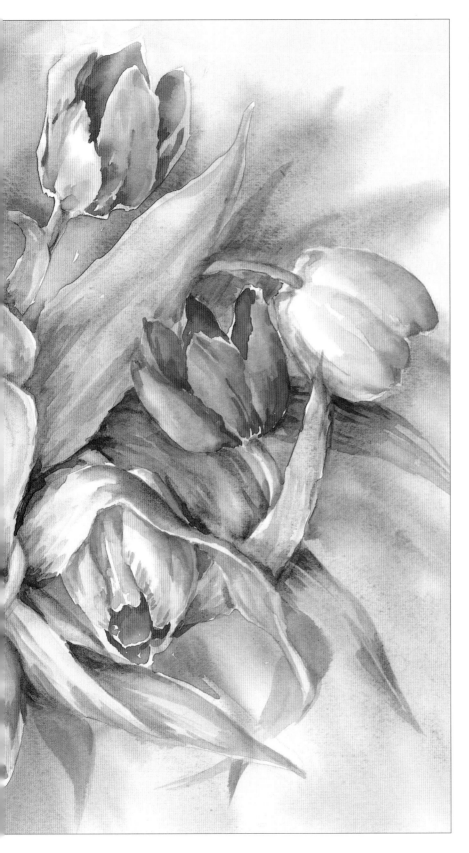

Tulips

This painting combines both warm and cool colours – pinks, violets and a warm golden background give it a glow, and the light greens are used to balance the effect. If the accent were on the blue-greens, the painting would look much cooler. The colours used are Winsor lemon, raw sienna, Winsor orange, scarlet lake, permanent rose, quinacridone magenta, Winsor violet, cobalt blue deep and brown madder.

Composing your painting

Once you have decided what you want to paint, set up your subject (or position yourself if you are outside) so that you have a good light source coming clearly from one direction. You will find it easier to paint if you can pinpoint exactly whether the subject is backlit or sidelit. If you can avoid a flat, overhead light, you will help yourself considerably.

Divide your paper into imaginary thirds vertically and horizontally, to create nine sections. Your main flower, or group of flowers (your 'ballerina(s)' as one of my students describes it) should cross one of these intersections and be just off-centre. It is best to keep them low in the painting. Begin with these and work outwards with softer, smaller flowers, keeping strong tones and contrasts towards the central group.

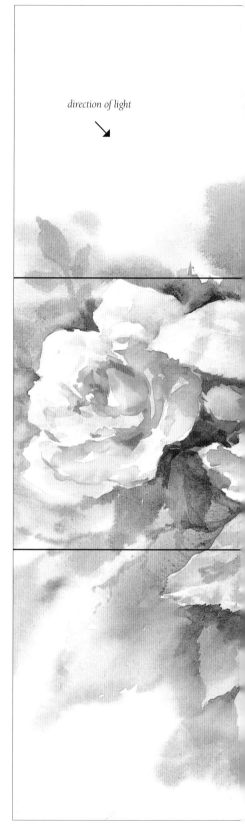

direction of light

Pink roses

I divide my painting into nine roughly equal sections. The ballerina(s), or main flower(s), will be located roughly in the middle section, just off centre, as shown by the circled area.

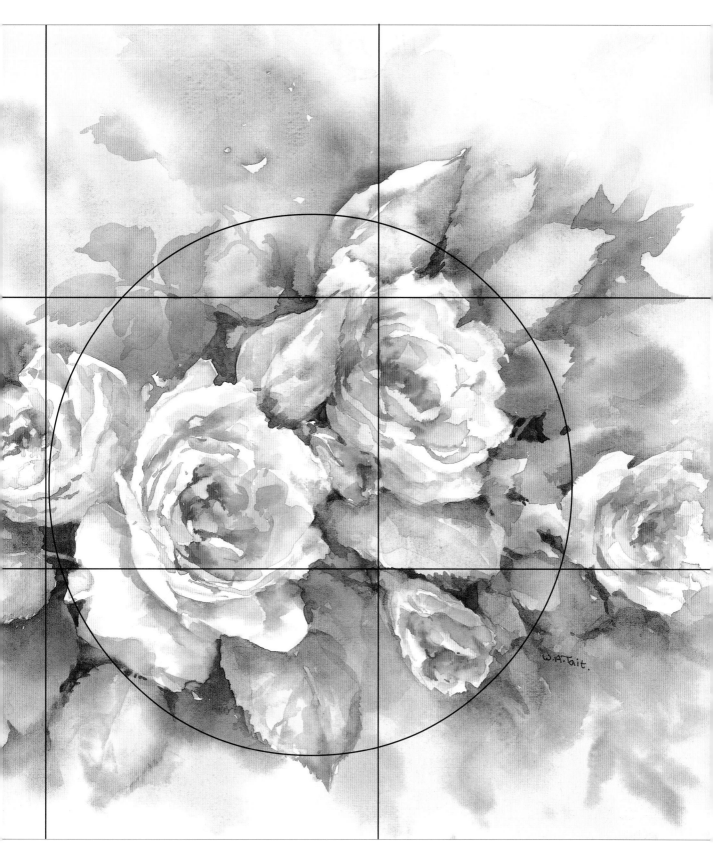

W.A.Tait.

Daffodils and catkins

This first project is a simple one painted straight on to dry white paper, and it includes just a trace of a background. The tones gradually deepen as the painting progresses; each time a deeper tone is used, a smaller area is covered. It is important to keep your tones very pale in the initial stages of the painting so as not to lose the light – you can always darken them later if you feel you need to.

I always prefer to work from real flowers. If they are in a vase, as these daffodils are, you can turn them as you work, to get the angle of each flower that you want. I tend to paint flowers approximately life size, usually on an A3 (16½ x 11¾in) or A4 (11¾ x 8¼in) paper block.

Before you begin, prepare some colour mixes in your palette. I have used a basic green mix of Payne's gray and Winsor lemon; a blue mix of cobalt blue deep with a touch of violet; a yellow mix of Winsor lemon and new gamboge, and a brown mix of raw sienna with a touch of Winsor violet.

Begin with a piece of paper larger than you think you will need. This allows for 'headroom' as your painting grows.

What you need
Winsor lemon,
 cobalt blue deep, Winsor
 orange, new gamboge,
 Winsor violet, raw sienna,
 Payne's gray

No. 10 or 12 round brush

Hake brush

1. Use the yellow mix to paint in the centre of the daffodil then add a little of the basic green mix to the centre. Deepen this green mix with a little cobalt blue deep then use this to paint the shadows, avoiding outlining the petals if possible.

2. Darken the centre with the blue-green mix. Add more new gamboge to the yellow mix to create a stronger colour, then use this to define the flower centre. Create a few shadows using a little raw sienna.

3. Paint in the trumpet of the second flower with the stronger yellow mix. Paint in two petals with the pale yellow mix.

4. Add details to the petals using a touch of the green mix. Paint in the centre of the trumpet using deeper tones of the yellow with a touch of raw sienna. Add clean water to the paint to dilute the colours towards the trumpet edge.

5. Paint in the third flower using the paler yellow mix and add the green mix to the base. Paint in the more deeply shadowed petals using warmer tones. Dilute the colour towards the edges, as in the previous step.

6. Use a warmer golden tone to paint in the trumpet. Use paler tones to strengthen the outline of the petals. Add raw sienna to the stronger yellow mix and define the crinkles at the edge of the trumpet. Use the same golden tones with a touch of violet to add the caul. Paint in the deep tone on the shadow side, then add water to the colour on the paper to dilute it slightly. Lift off a little colour with your brush to suggest light coming from above.

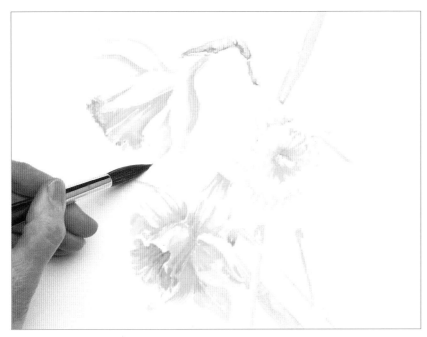

8. Paint in the catkins using raw sienna and Winsor violet added to the green mix. Leave to dry thoroughly.

7. Use the basic green mix with a touch of cobalt blue deep, to paint in the stems. Leave areas of white where they are highlighted. Add the leaves, blending and diluting the colour where the leaves turn.

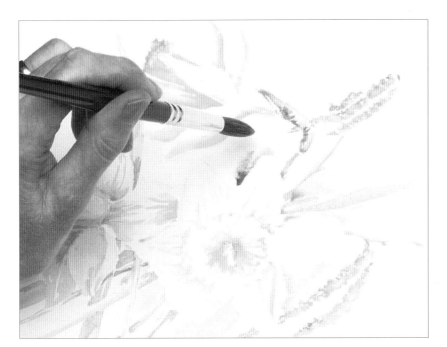

9. Wet the white paper behind the flowers using the round brush, then use the hake brush to wet the large area right to the edge of your paper. Use the round brush to drop in a mix of cobalt blue deep with a touch of violet, making sure the colour runs and deepens behind the flower.

Note *Work from the outer edge of the petals in towards the centre or more deeply-toned area to avoid hard edges. Sometimes, you may find it helps to turn your paper as you work.*

Daffodils and catkins

Adding just a little background colour right at the end, pulls out the central daffodil. Note that the trumpet is slightly off-centre so that the stamens give an idea of the shape.

Primroses, pansies & heather

Watercolour is a wonderful medium if you allow for 'happy accidents' and let it flow. For this reason, I do not draw with a pencil – I find it much more exciting to never quite know what will happen! Many students find this terrifying, but once they try it, they find it exhilarating too. Drawing with a brush means that you do not ruin the surface of the paper with pencil marks, nor do you have the temptation of always rubbing your work out and starting again. It is not as difficult as it sounds, and painting this way means that a unity develops throughout.

The photograph on the right shows my subject. As I begin painting, I may decide not to include everything that is in front of me. I want the freedom to be able to change the composition so that it will grow in a natural way. I often like my main subject to be the palest as it gives me plenty of scope for rich background contrasts. It is a good idea to spend some time deciding which part of the subject appeals to you most. Study the subject first in detail, then with your eyes half closed. This will help you to decide on your tonal values.

Before you start painting, you should have a rough idea of where you want to position the flowers. However, after applying the initial background washes, you may find that you need to readjust the composition, depending on what has happened on the paper. This is easily done by laying in new shapes and tones.

Before you begin, mix large puddles of your background colours – these should be almost the same as your subject colours.

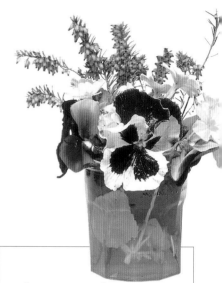

What you need

Quinacridone gold, new gamboge, permanent rose, quinacridone magenta, Winsor violet, cobalt blue deep, brown madder, Winsor lemon, Payne's gray

No. 10 or 12 round brush

Hake brush

1. Wet your paper thoroughly using a hake brush. Change to a No. 10 or 12 round brush and drop in Winsor yellow, cobalt blue deep, permanent rose and a basic green mix, allowing the colours to mingle slightly. Leave light areas where the flowers will be.

Note *Dropping in colour means literally that – the brush hardly touches the paper. This will create a soft background, with no brushstrokes.*

2. Allow the paint to dry slightly then lightly paint in the heather using Winsor violet mixed with permanent rose. Remember that this will be emerging from behind a light pansy, so do not take the stem too far down. Use a little of the green mix on the base of each flower stem. Deepen the tones behind the flower.

3. Place the primrose centres with a little deep yellow (quinacridone gold added to Winsor lemon to give a warm tone). Lightly sketch in the flowers using pale yellow with a touch of blue and green. Each outline can be used as a shadow for the next flower. Soften shadowed areas with a clean brush.

4. Use a diluted mix of permanent rose to paint in the first (pansy) petal, then add Winsor violet shadows. Paint in each petal separately, working with diluted pink (permanent rose) on the outside, then adding more colour towards the flower centre. When the petals are dry, add a touch of quinacridone gold in the centre. Leave to dry.

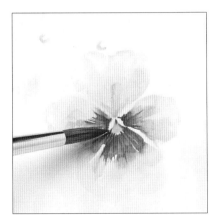

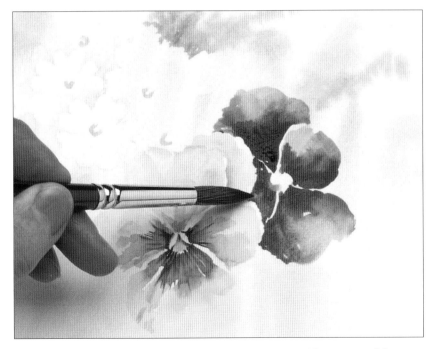

5. Add more gold, then use a mix of brown madder and Winsor violet for the veins. Work from the centre out on each petal – this is one of the few times you do not work from the outside in. Add a touch of darker tone in the flower centre. Paint the shadowed petal using the same pink with a little violet added.

6. Lay in the second pansy using violet and diluted brown madder. While the paint is still wet, add a much stronger mix of this colour towards the centre of the flower.

7. Use a very diluted mix of green and cobalt blue deep to paint in the white part of the third pansy. Add quinacridone magenta to the violet and brown madder mix, then paint in the darker petals and flower centre. Paint in the very centre with yellow.

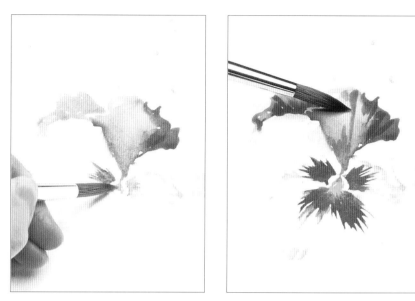

8. Add the veining using a mix of Winsor violet, brown madder and cobalt blue deep. Use light violet to suggest shadow and form. Add a hint of yellowy green where the white petals are in shadow.

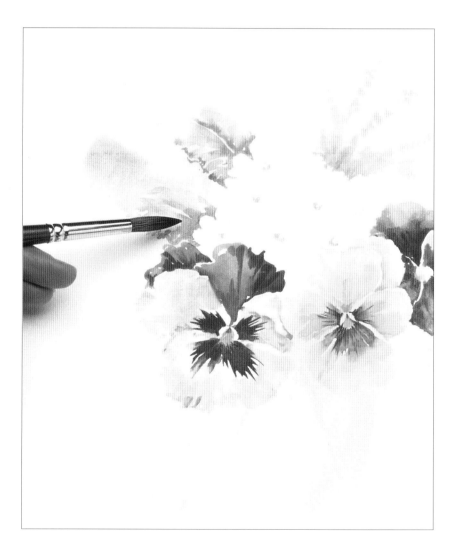

9. Define more primroses using a diluted yellow mix. Lightly lay in the stems. Use the green mix to lay in the primrose leaves. While the colours are wet, add deeper tones towards the flowers and around the central veins.

10. Suggest highlighted areas by adding darker tones to some of the primroses. Add detail to selected primrose centres using quinacridone gold. Use a mix of gold and a little green to paint a small horseshoe-shaped shadow into the very centre of each primrose.

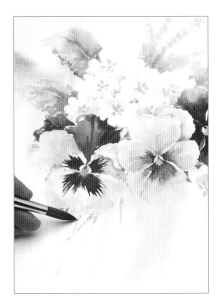

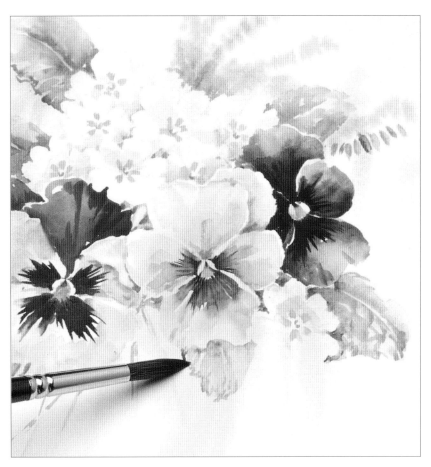

11. Add a yellow centre to the second pansy, then lay in the veining using the deep, rich mix of brown madder, Winsor violet and cobalt blue deep. Where necessary, redefine shapes and correct or soften areas of colour. Paint in another primrose to balance the composition, then strengthen the colour of the stems.

12. Add another leaf in the foreground to define the edge of the pink pansy and to balance the composition. Paint a yellow glaze over the leaves to soften the colours.

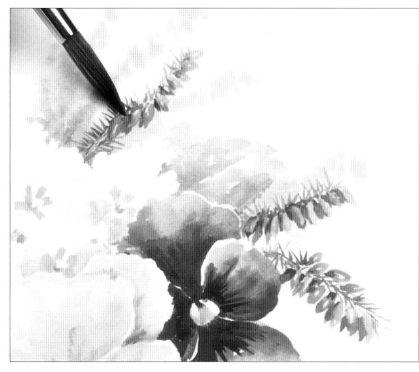

13. Add more detailed heathers using quinacridone magenta. Add shadows with a little Winsor violet. Add green spiky stems using dry brushstrokes to create crisp, clean outlines.

14. Turn the painting upside down. Wet the background using a hake brush. Change to the round brush and run blues, greens, pinks and violets into the wet background. Tilt the paper to ensure that the colours run down towards the flowers, making sure that the flowers themselves are absolutely dry to create a barrier.

15. Turn the picture the right way up. Deepen the background tones underneath the flowers and leaves and strengthen the stems.

Primroses, pansies and heather

*This simple little painting of some of my
favourite flowers, illustrates how well pale
primroses show up when just a little foliage and
background are dropped in behind them.*

Anemones

These anemones were a really rich, warm purple, so I decided to keep the background colours to a minimum.

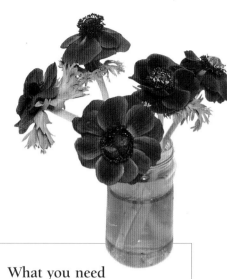

For this painting, my light source was coming from the top right – bear this in mind when working through the project.

Before you begin, study the flowers carefully and then mix up your colours. Start painting with pale or mid tones. Remember that you are trying to paint the light falling on to a deep purple petal, not the true colour you know it to be. If you half close your eyes, you will see that only the shadowed areas are really dark, either close to the central cushions or where one petal crosses another. Try not to outline petals, but use a full brush of dilute colour starting from the outer edge. Allow colour to deepen towards the centre. Remember that every time you use a deeper tone on a petal, you should cover a smaller area than previously, so the final darks are really minimal.

You do not need to reload your brush as frequently as you might think. The same brush-load can often be used to paint several petals quickly, getting paler as the colour is used.

What you need

Winsor lemon, new gamboge, Payne's gray, permanent rose, quinacridone magenta, cobalt blue deep, Winsor violet

No. 10 or 12 round brush

Hake brush

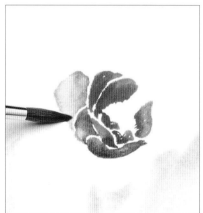

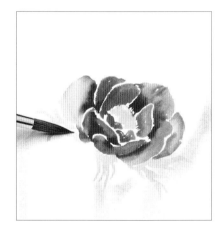

1. Wet the paper with a hake brush. Use a round brush to drop in a little Winsor lemon to give a background glow. Now introduce a little violet and blue mix. Drop in some of the green mix and pull it out to resemble the shapes of the leaves. Remember to leave spaces for the main flowers. Suggest one or two stems as you work out your composition. Leave to dry.

2. Paint in the first petals using a stronger violet mix than used for the background. Leave fine white lines between the petals. These can be filled in later if necessary. Deepen the pigment to work shadowed areas. Add a touch of permanent rose to the violet mix and use this for the outer petals. While the paint is still damp, drop in deeper violet tones at the base of each petal.

3. Use a pale wash of the green mix to paint in the centre. Use the colour left on the brush to pull out a few leaves.

Note *If an areas dries before you are able to follow the instructions, you can always re-wet it and start again. However, make sure the paper is completely dry before you attempt this.*

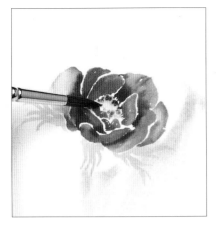

4. While the centre is still damp, go back in with quite a strong mix of Payne's gray and Winsor violet. Deepen the tones of the leaves where they are shadowed by the flower.

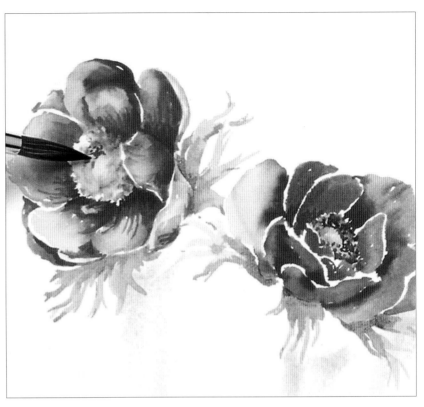

5. Paint in the second flower in the same way and using the same colours as the first one. Add detail to the centre of both flowers using a more intense mix of the Payne's gray and Winsor violet.

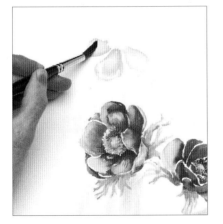

6. Paint in the third, palest flower at the top using a diluted mix of permanent rose and Winsor violet.

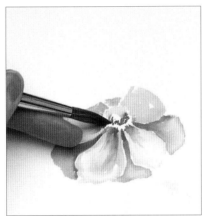

7. Add darker tones to create the shadows and use this same colour for the under layer of petals. Paint the centre of the flower using quinacridone magenta.

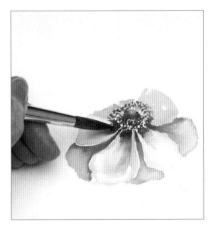

8. Add detail to the centre cushion and paint in the stamens using a strong mix of Payne's gray and violet. Deepen the dark pink shadows even further using quinacridone magenta.

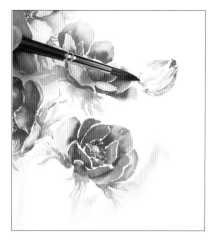

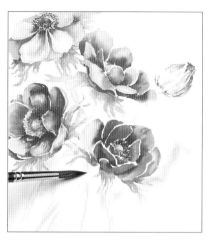

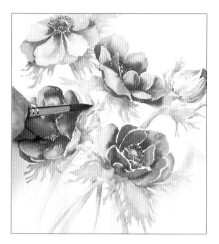

9. Add leaves to the third anemone, then paint in the fourth using the same colours and methods as the first two flowers. Paint the bud pale green and add violet to the shadow side and base to give a velvety look. Remember to leave plenty of light to allow for the shine on the petals.

10. Use the green mix to position the stems.

Note *Flowers rarely have completely straight stems. Curving them slightly will help your composition and create a more natural-looking painting.*

11. Add the centre to the fourth flower. Thicken up some of the leaves, especially the ones around the lower flowers. Add shadows where the stems cross and on the side of the stems away from the light. Introduce a little of the violet flower colour into the stem.

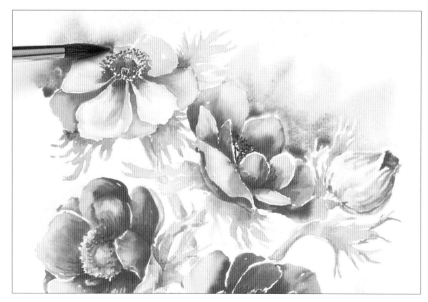

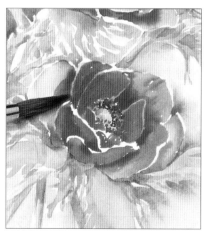

12. Wet the background in sections, then drop in Winsor lemon, the basic green mix, cobalt blue deep and Winsor violet behind the flowers. Tip the paper quickly as you work to move the colour where you want it, so that you have deeper tones behind the flowers. Allow each section to dry before going on to the next.

13. Adjust the tones of the flowers if necessary and deepen areas as required. Wash over some of the white lines between the petals using a very diluted pink mix. This will soften any edges which are a little too hard.

Anemones

When painting strong-coloured flowers such as anemones, remember to keep most of the petals pale (you should aim to paint the light falling upon each one) and only allow deep colour in shadowed areas.

Fuchsias

Fuchsias come with a readymade background of leaves – these can be dropped in using pale tones in the first stage, taking care to leave lots of light areas where the flowers are planned. The tiny dark, negative painting areas (see page 46) should be most intense behind the 'ballerinas'.

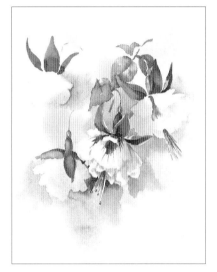

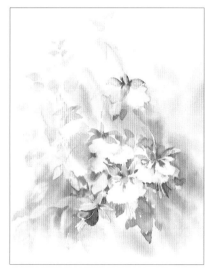

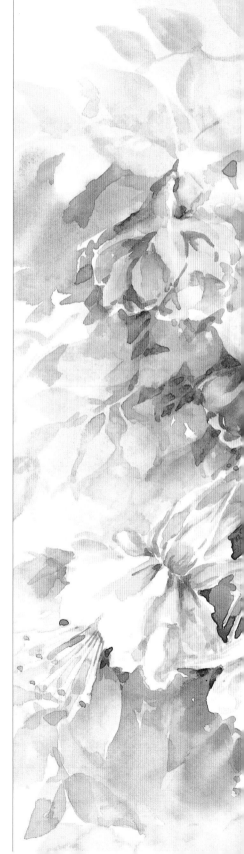

Part-worked fuchsia (1)
This shows some negative painting, i.e. darks behind the flower. I have taken the central flower to its finished state for demonstration purposes. Normally, I would leave these small darks till later in the painting.

Part-worked fuchsia (2)
Note the white flowers painted over a green or blue tint and the use of negative painting around them to show them up. The tinting on the flowers provides the shadow.

Fuchsia
This picture is cooler than the studies above, as the fuchsias were much more lilac and blue in colour. Even the pale pink ones are shadowed in pink mixed with blue. Note the tiny intense darks, which give the effect of throwing the pale flowers forward.

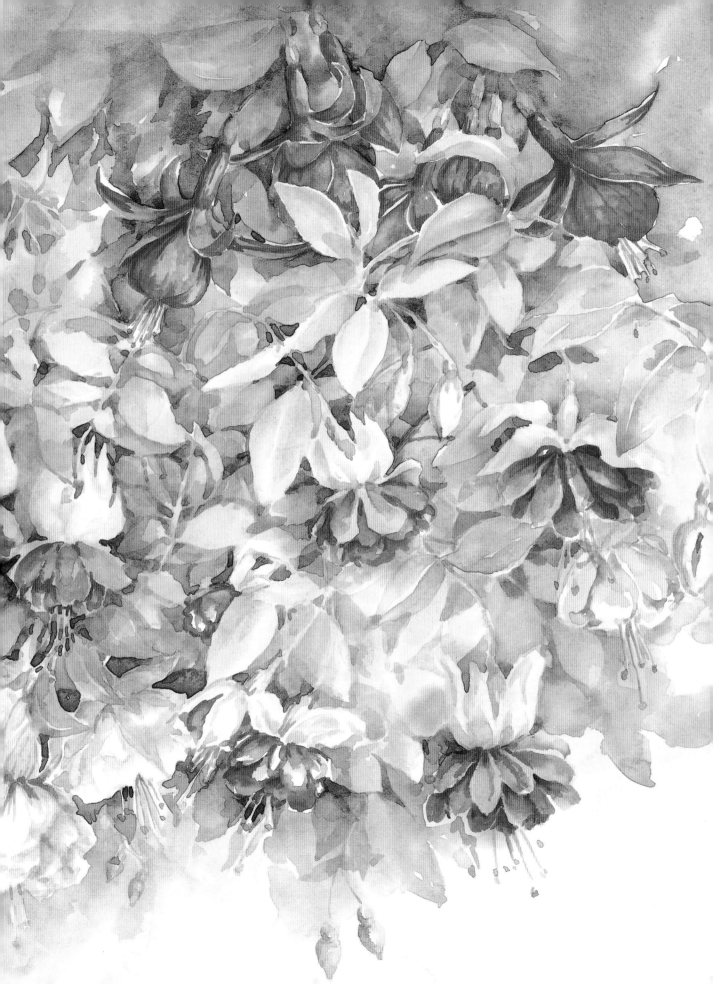

Cyclamens

These delicate flowers have a lovely butterfly shape and care must be taken not to become too heavy with the colours. The leaves deserve attention too, but I frequently shorten the stems of the flowers by looking down on them, instead of viewing them at eye level. This is a good tip for many long-stemmed flowers, as the leaves then create a background leading up to the flowers, instead of leaving an uncomfortable gap.

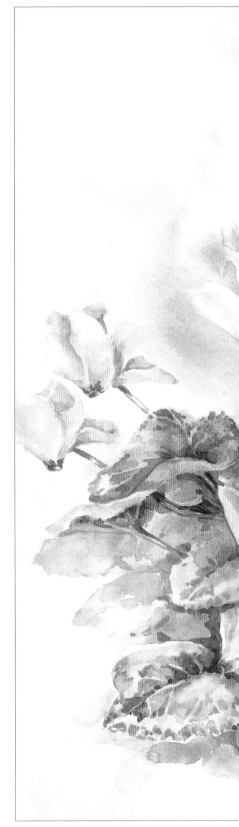

Part-worked cyclamen (1)

Here, I have painted in a very pale background wash using Winsor lemon, cobalt blue deep and a green mix. I drew in the composition of the leaves with loose brushstrokes while the background was slightly damp.

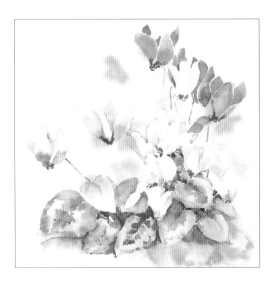

Part-worked cyclamen (2)

These cyclamen are again painted using pale colours – permanent rose and quinacridone magenta. I have left many light areas for the flowers. This study shows the stage of deepening the colours on and around the leaves.

Cyclamen

I decided to make this a cool painting, adding plenty of
blue to the background and the shadows on both the
flowers and the leaves. My subject was actually three
pots of cyclamen placed very close together so that the
pale flowers showed up well against the deep pink ones.
It is not necessary to detail all the leaves as the
imagination will supply any missing information.

Roses

The key to painting roses is to relax – it does not matter if you are on the 'wrong row' of petals – only you will know. I am sure you will find your own way to paint these marvellous flowers, but here are a few tips worth remembering to set you on your way:

- Rose thorns always curve downwards

- The veins are rarely seen the whole length of the leaf

- The shine on the leaves of roses (and ivy and holly) is blue in shade

- When painting a red rose, paint in quite a pale colour to begin with, then paint in the deep tones later

- When painting a pale rose, remember that a little paint goes a long, long way

Opposite
Roses and larkspur

These simple roses were painted very quickly for a demonstration – there was no time to 'fiddle', and so the result is fresh and informal. However, notice that as a result of working so quickly, this is not a good composition; the main flower is much too central and the three roses form a line. This sometimes happens with a demonstration piece, when I do not have time to step back and evaluate. It is all part of the learning process!

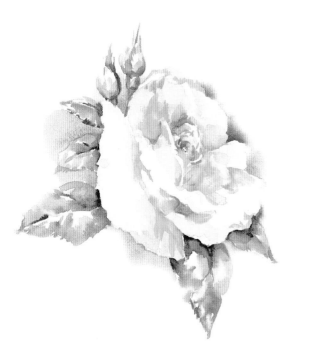

Rose studies

These three roses are painted loosely from photographs – this is a good way of painting roses in the winter! Do not try too hard to make an exact copy of the photograph, but use the time as a practice exercise only, to help you prepare for painting from life later in the year. Note the cool tones on the outer petals of the pink rose, and the warm tones in the centre of the white rose. The centres of all the roses have been painted without too much detail, leaving a little to the imagination.

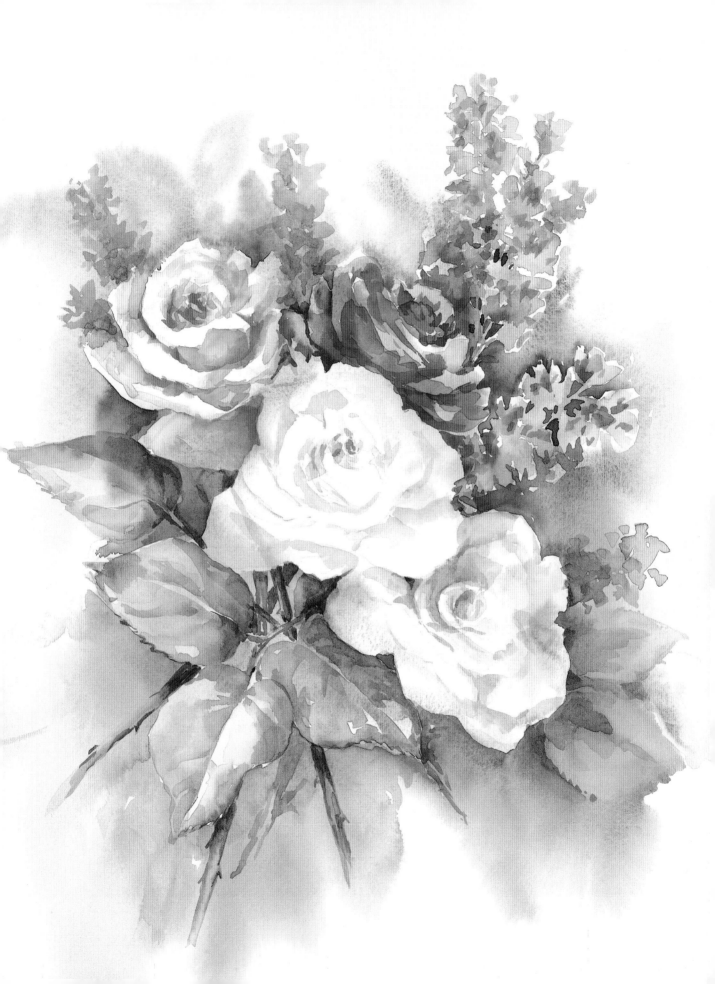

Garden roses

My basic green mix was used then gold
and raw sienna were added to warm the
greens and give them the deep tones.
Notice how the intense darks only cover
very small areas.

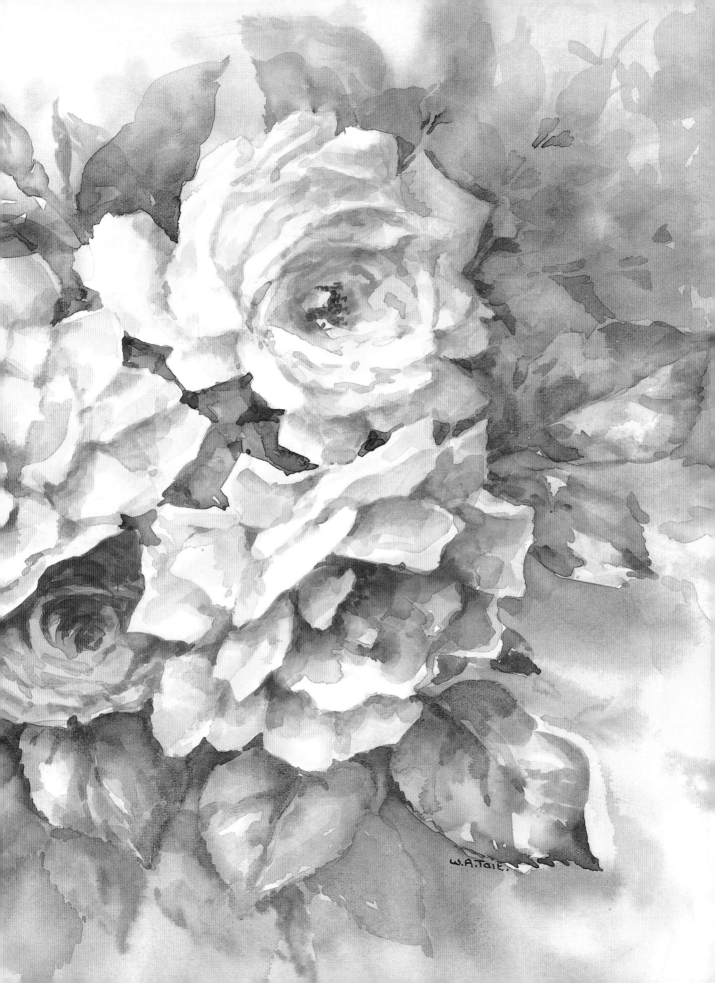

W.A.Tait.

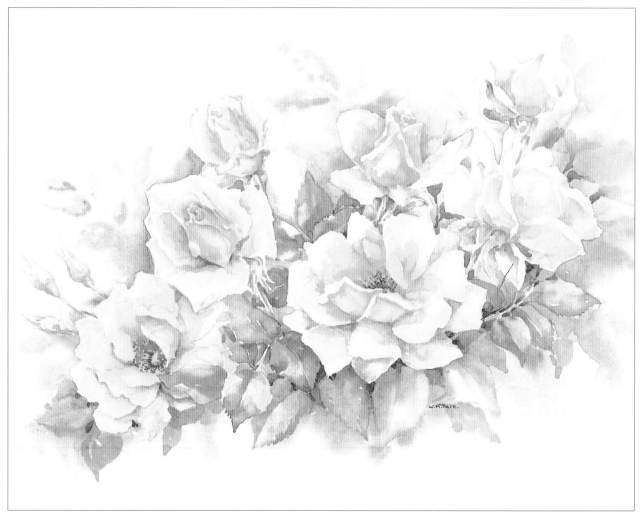

King's ransom
These fabulous yellow roses are painted on smooth paper which gives a very crisp, clean effect. I painted the flowers first and then added the background last.

A mixed bunch

There are literally hundreds of types of flowers and most of them make excellent painting subjects. The next few pages include just a few examples – from elegant irises to loosely worked poppies and daisies.

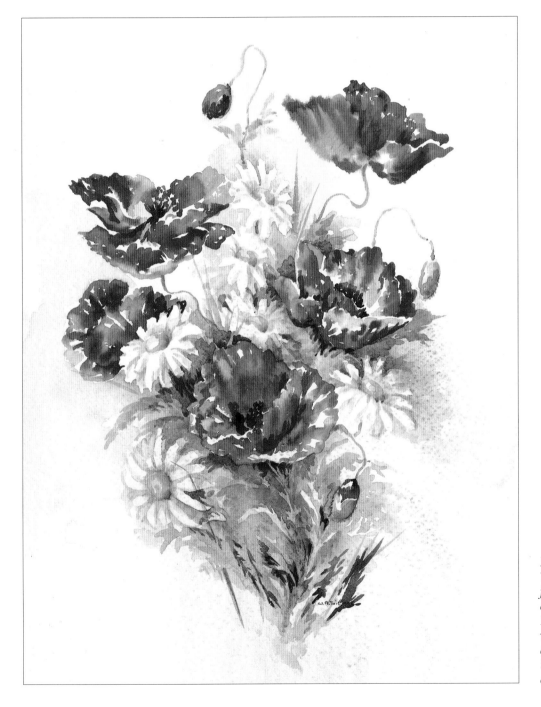

Poppies and daisies
This is quite a loose, free painting, worked on Rough cream paper. I enjoyed painting this very quickly and avoided overpainting, to keep it looking fresh and clean.

Summer garden
This simple study incorporates various strongly-coloured flowers which are loosely painted in order to throw the white daisies to the foreground.

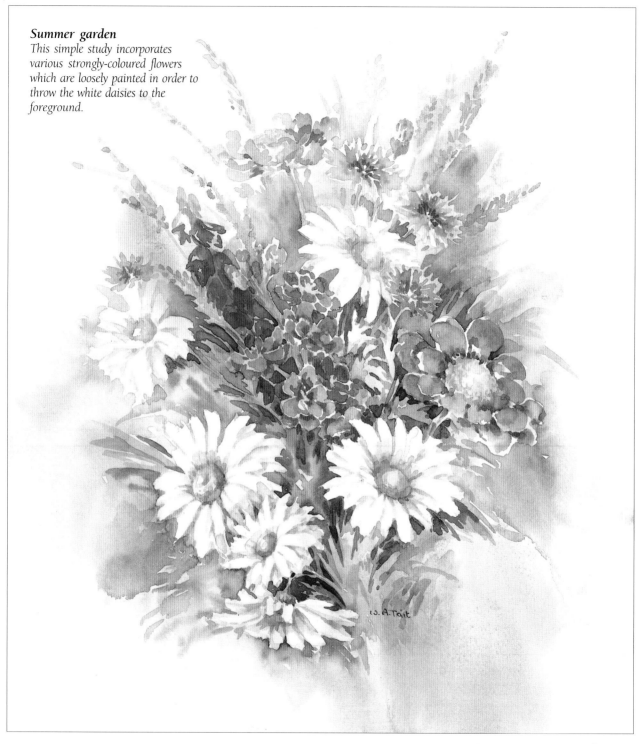

Opposite
Hazel's irises
This painting has been borrowed from my daughter. Although painted some time ago, I still like the effect of these stately flowers.

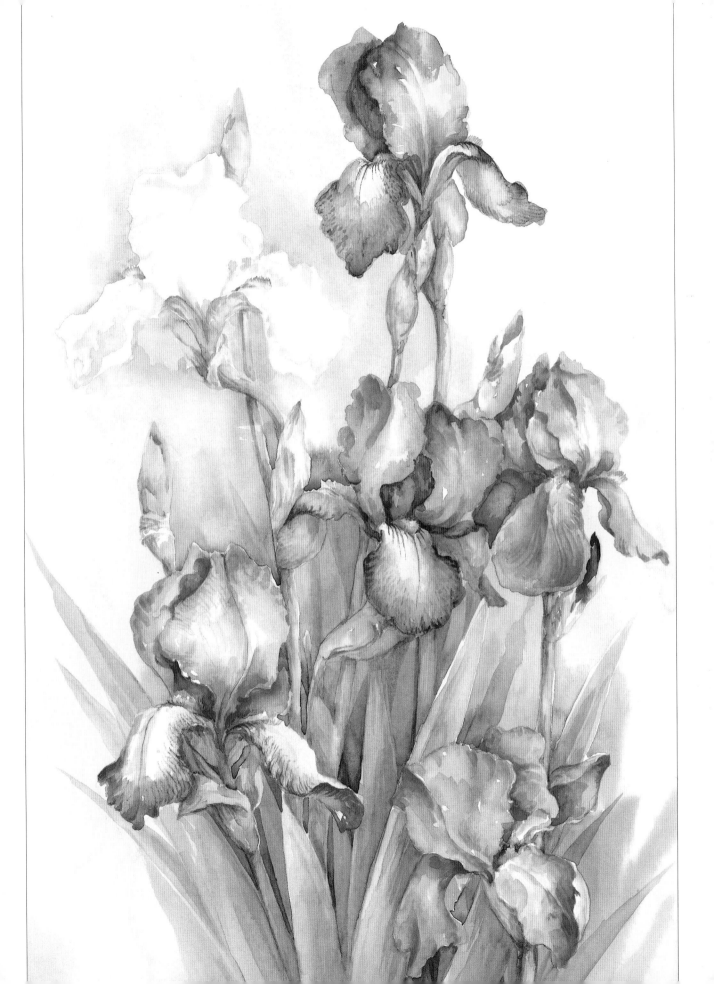

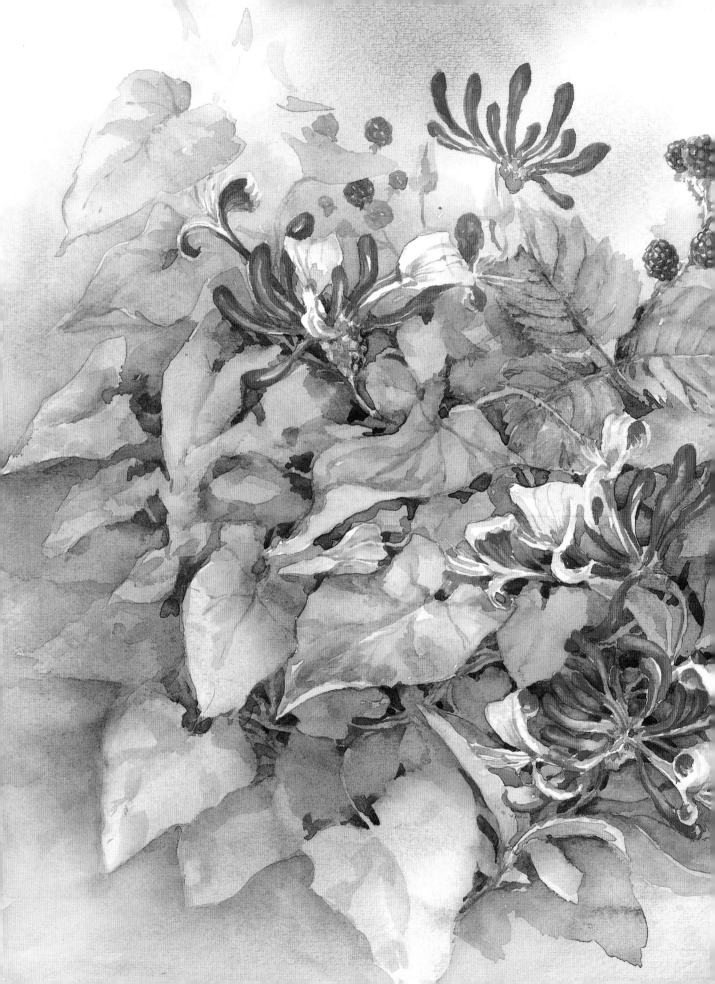

Brambles and bindweed

Although not welcome in my garden, I love to paint bindweed. Painting this tangled hedgerow was quite a challenge, but also deeply satisfying. I think the contrast between the white flowers and the rich tones of honeysuckle and blackberries works really well here.

W. A. Tait.

Painting terms explained

Although I have included four illustrations of painting terms here, any one of them can actually be applied to each of the examples. All the compositions contain elements of counterchange, negative painting, lost and found edges and aerial perspective. Although these sound like complicated terms, they describe simple things – in fact, you are probably already achieving what is covered here, without thinking about it!

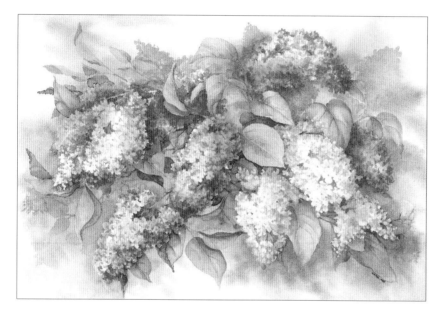

Lost and found edges

This is a term used to describe how soft and sharp lines can both be used to define elements in a painting. The lilac blossom here sometimes emerges with a sharp (found) edge, against a background of leaf or shadow, or it appears to be indistinct, and its edge becomes lost. The bindweed and brambles (pages 44–45) is another good example of this, with its sharp, tangled hedgerow and soft misty leaves.

Counterchange

In simple terms, counterchange means light against dark, dark against light. It is used to emphasise elements of the painting. In this example of cherry blossom, the pale pink blossom has been painted against darker pink blossom and the very dark background is placed behind light areas. Also note the little dark buds against the pale background.

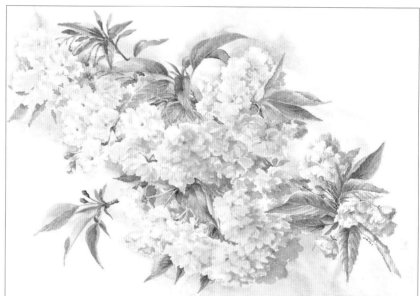

Negative painting

The way to create a delicate flower is to paint the background, not the flower. This is called negative painting and it can be used to great effect. It is a way of suggesting form by painting the negative rather than the positive image that you see. For example, in this loose painting of foxgloves and daisies, you can see how the white daisies are created by the little dark shapes around them – these have been carefully painted to suggest leaves and half-seen flowers. Another example can be seen in the small areas between the stems as they cross each other.

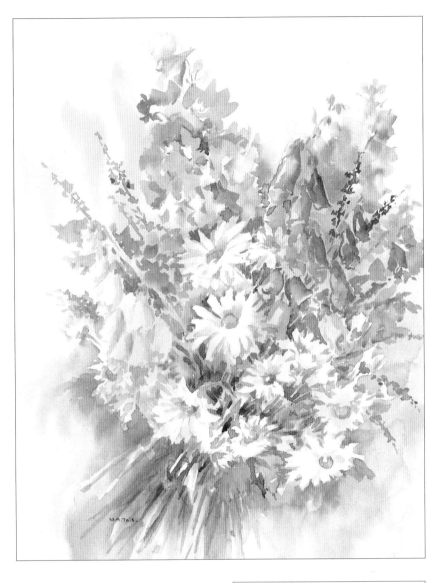

Aerial perspective

Aerial perspective is used in landscapes to show how objects close to you are larger and stronger in colour, tone and detail, than those further away. It is used on a smaller scale with flowers too, to make sure the eye is drawn first of all to the three 'ballerina' roses. Note the detail and warmer tones used on the large roses in the foreground and compare them to the background roses and leaves.

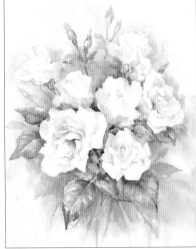

> **Note** Successful painting is often about timing. The exact moment to deepen a slightly drying wash (usually when the shine goes off the paper) can only be learned by trial and error. Only many hours of experimentation can teach you this kind of technique!

Index